Colors of Christmas- Telem

Table of Contents

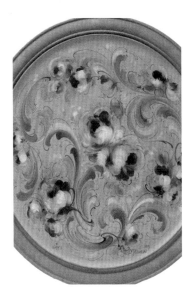

Lesson 1- 17

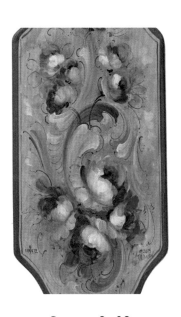

Lesson 2- 32

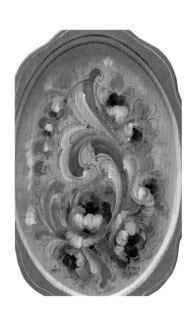

Lesson 3- 46

Published by
Jansen Art Studio Inc.
Elizabethtown, PA USA
David and Martha Jansen

Multimedia Content
Jansen Studio Productions
Ironville, PA USA
Jessica Jansen & Dave Parmer

Copyright Notice

Filberts or Flats? What Brush to Use.

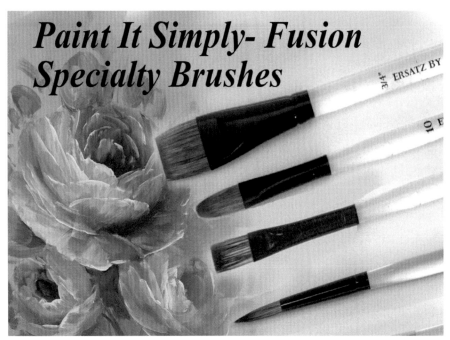

Paint It Simply- Fusion Specialty Brushes

Brushes Used for These Lessons

Brushes by Global Art Supply
These lessons are painted with the fusion flats and filberts. You can use either the flat or filbert in these lessons.

Brushes I used in these lessons
Fusion Filbert Size 6, 8 or 10
Fusion Flat Size 3/4 inch.
Watercolor Round # 4 or # 8
Raphael 16684 # 3 Quill for some liner details.

Fusion brushes must be used for these techniques. Attempting to use other brands and types of brushes will only lead to frustration. This is an American made brush that is very versatile. The brush hair is a synthetic squirrel and is very soft. It is much softer than normal acrylic brushes. This allows the artist to achieve a softer look to the painting with fewer strokes. This is very desirable for the techniques shown here because, with the Paint It Simply lessons, we don't want to blend. Achieving a soft look quickly is desirable.

Heritage MultiMedia® Paint System

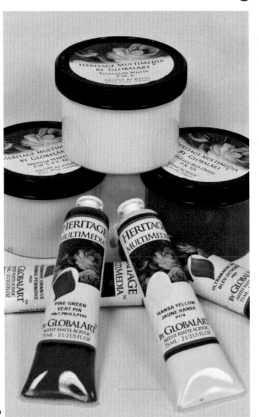

Not all acrylics are the same. As a matter of fact, industry standards dictate controls over the labeling of acrylics as to quality and durability. For example, most bottle acrylics are not "artist" quality. To be labeled "artist quality" the paint must have little to no filler added. The artist quality paints are designed to be mixed together to form new and historical colors. Be careful when selecting paint and make sure you are using the best quality that you can afford.

For this book we are using Global Art Supply's Heritage Multi-Media® Acrylics. The techniques described in this book have been formulated to work with this paint line. **Substitution of brands is not recommended** as the mixing and technique results will not be the same, and you will hinder your ability to learn the techniques.

Heritage MultiMedia® is a resin based acrylic that can be easily converted into watercolor, Global Colors (oil emulsion), and tempera colors. Basically, the artist controls the paint film and not the company.

Preparing the Surfaces for Rosemaling Designs

For these lessons I use wooden plates or plaques that we sell. Please see JansenArtStore.com for purchasing. I wanted the surface to be matte and soft. I base coated the desired surface with color, let it dry, then sanded lightly to remove roughness.

Step 1

Mix desired color as shown in each lesson. Apply with soft brush or sponge shown here.

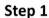

Step 2

Sand the surface with 150 to 220 grit sand paper to smooth. Do not use too fine a paper such as 400 because you will make the surface too slick.

Step 3

Transfer design or sketch with pencil. Follow next directions from each individual lesson. Give the surface a light transparent coat of paint and Extender.

Step 4

When coating the surface do not have too much paint or too thin (watery) paint. This will make painting the design difficult. Just use a light coat and stretch it out.

Varnishing Your Finished Painting

Heritage Varnishes are a state-of-the-art clear, non-yellowing, resin-based polyurethane varnish. They brush on smoothly and are self-leveling so that the artist doesn't have to stroke and stroke to smooth it out. It will give the quality protection of a Polyurethane varnish with the ease of application you enjoy from acrylics. Heritage Varnish is excellent for both interior and exterior use. When dry, it creates a hard, durable satin, gloss or matte finish that is ideal for artwork on a variety of surfaces. It dries quickly in 5 to 10 minutes, depending on weather conditions. You can slow that drying time with the addition of Extender Medium to the Varnish. For best results, thin the varnish with a little to equal amount of water. This makes application easier. Mix varnishes to create desired sheen. To make a Satin finish mix the Gloss and Matte Varnishes 1 to 1. Heritage Varnish is compatible with all Heritage paints and mediums. It is non-toxic and cleans up with soap and water. Because it is an acrylic product, it should not be used over oil based products.

Directions: Surface should be dust free and completely dry. Shake well then let the bottle stand for a few minutes. Apply with a brush or sponge. Varnish is easier to apply if thinned with water. Apply with a wet brush. Mist the surface with water if varnish begins to dry before you have finished varnishing. You can lengthen the drying time with the addition of Extender Medium. Additional coats can be applied as soon as the last coat is dry. Rinse brush thoroughly after use. Clean up with soap and water.

Two coats are sufficient for indoor use, three coats for exterior use. When applying multiple coats of varnish, allow NO MORE than 24 hours between coats. If you wait more than 24 hours, a light sanding with 400 grit sandpaper can be done to create better "tooth" for the final coat.

Color Thoughts- Paint It Simply- Art of Painting

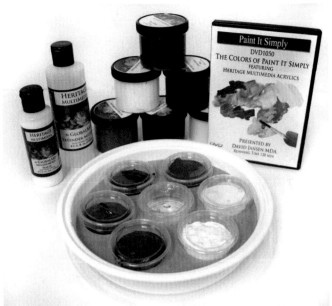

Paint It Simply Limited Palette Kit

The goal of the Paint It Simply educational program is to create a customized color palette. However, in order to choose the most effective colors for your designs, you must understand pigments and color mixing. The program starts out with 6 basic colors: Carbon Black, Titanium White, Naphthol Red Light, Red Violet, Phthalo Blue and Hansa Yellow. The program has over 500 lessons written with this limited palette. All you have to do is learn 6 colors.

As you move into the Art of Painting Techniques, we introduce additional pigments and color mixing. The goal of the Art of Painting is to teach you about more pigments so you can design your own color palette.

During the 1980's and 90's paint companies, especially bottled acrylic companies, produced hundreds of paint colors. This was good, in that, it allowed new artists to paint quickly without knowing about color- just choose a bottle. Now we are seeing the long term effects of that strategy. Artists learned to paint without understanding the most important concept in painting: Color. Designing and painting your own ideas is a difficult task without understanding simple color concepts. A little color knowledge goes a long way as we will show you in these lessons.

Finding Your Brush- The Art of Painting

Another goal of Paint It Simply and the Art of Painting is to find your own brush. Your way of painting. There are so many brushes to choose from today. With the invention of synthetics in the 1980's many new types of brushes were developed. Artists of old used just a few types, hog hair bristles and natural squirrel or natural hair brushes. Today, I

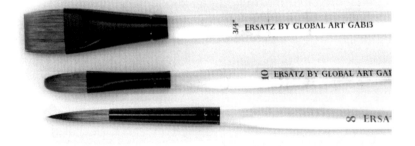

divide brushes into 3 categories: Natural, Synthetic and Bristle. Bristle brushes are used to push thick paint around. Synthetic hairs snap very quickly in your hand so they are good for Rosemaling and other stroke techniques. Natural hair brushes, such as Kolinsky sable and squirrel hairs are beautiful brushes but very expensive. I use them for casual techniques and areas where I want a lot of soft painting without the digging that a bristle or synthetic can do on soft layers of paint.

What is your brush? Everyone's hand is different. This means that everyone likes different brushes. I choose my brush depending on the technique. For the Art of Painting, I lay colors on top of other wet colors and do not like them to blend. This is why I use natural and fusion brushes. The fusion brush was created about 10 years ago with new technology that allows us to make a synthetic squirrel brush. For me, I choose a brush by the hair. Whether you use a filbert, round or flat is not important. It is the hair that pushes the paint. Many times I paint with just one or two brushes. Choose the correct hair and the technique is easy. Choose the wrong brush and it can be difficult.

Making Global Colors using the Global Palette

To make Global Colors, we need to evaporate some of the water from the paint, and replace it with our concentrated Extender Medium.

How long does it take?

hat is a difficult question to answer, because evaporation is different is various parts of the country. Generally 24 to 48 hours. The longer you leave the color open to evaporate water, the longer the open time of the final paints. You can achieve a 30 hour drying time if left open for 1 week.

How long can I store the Globals?

Generally if you paint every few days, just put the lid on the palette and that is enough. If you are not going to paint for 1 week or 1 month, cover with press and seal before applying the lid. Properly stored the self life is indefinite. We have some Global Palettes that are perfect and 4 years old! Take care of your palette. With proper care and storage the paint will remain moist as in the tube. If you do not store properly, the paint will dry out!

Step 1

Step 2

Step 1
Fill the desired well 1/2 to 3/4 full of with the desired color of paint.

Step 2
Add about 20% to 25% Heritage Extender. No need to be perfect! Close is OK!

Step 3

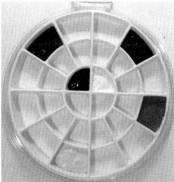

Step 4

Step 3
Mix the color and Extender very well. This is important. Mix until the paint is creamy.

Step 4
Let the color stand for 24 to 48 hours while water evaporates. Stir the colors every 6 to 8 hours to help the evaporation of water.

Step 5
To store colors for a long time, cover the palette with Press and Seal before putting on the lid of the Global Palette.

Step 5

Step 6

Step 6
For longer storage you can mist the lid of the Global Palette with distilled water. Do not mist the paints.

Greens- Leaves, Scrolls
Hansa Yellow will make a wide variety of greens. On the left you can see Hansa mixed with Phthalo Blue on the right tiny touch of Carbon Black. Combine both for more greens!

Yellows- Flowers, Leaves, Scrolls
Hansa is a bright yellow. I like to use it soft. Add some browns (shown below) and touches of Red Violet and red add more variety. White lightens and opaques the yellow.

Reds- Flowers, Leaves
Naphthol Red Light is a warm red orange. Red Violet is a cool red violet. Mix together to make a wide range of reds and lighten with white to make soft pinks.

Blues- Flowers, Leaves, Scrolls
Phthalo Blue on the palette is a dark blue which leans to the green side. If you add a tiny touch of Red Violet, then lighten with white, you will make a wide variety of blues and blue violets.

Oranges- Flowers, Leaves
Hansa Yellow can be used as a base for a wide variety of oranges. Tiny touches of Naphthol Red Light make warm oranges and touches of Red Violet make cooler oranges.

Browns- Flowers, Leaves
Base Brown is 2 parts Naphthol Red Light and 1 part Carbon Black. I vary this color in many brush mixes with additions of Hansa Yellow which lightens and make more sienna colors.

What happens to Yellow? The red will warm, but the black will cool. If you increase the black, the color becomes greener and cooler. If you increase the red, the color become more orange and warmer. The second mix shows Red Violet and Carbon Black. Here you will always make the color cooler since both colors are cool. There are many ways to cool a color. The last shows Hansa Yellow and Black making greens. The green cools from left to right because Black is cooler than Hansa. Add Red Violet

and the color cools even further.

Color tone refers to the mixing of a neutral color with a pure color. For example, if I take Hansa Yellow ,a bright, slightly warm yellow, and add a touch of light grey, I have made a tone of Hansa or a tonal color of Yellow. This is a broad definition of the term.

In this book we will not use the grey tonal values of color. We will not mix black and white to make grey and then add that to a pure color.

In this book, we mix complimentary colors which make greys that have more life and better harmony with the other colors in the palette. Lets look at some examples and how we can add "tonal harmony" to our colors.

Above, I have mixed Hansa Yellow with the tonal range of white and black. This is a broad definition of tonal color-making: a tone that is a softer, less intense tone of Hansa Yellow. This is a Tone of Yellow.

The second example uses Phthalo Blue, Naphthol Red Light, and Titanium White. This makes a "tertiary color." Tertiary means 3. The three primary colors are red, yellow, and blue. When these 3 colors are combined in any variation, they make a "tone" of a color because they make a "tertiary"grey. Add white to lighten the color to the value of Hansa, thus making a grey tone or Tonal Yellow.

Temperature of Your Colors

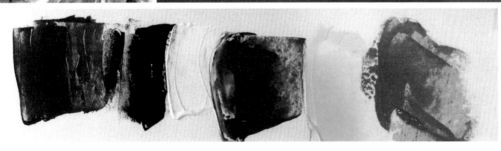

Cool Color		Neutral		Warm Temperature
Red Violet	- Carbon Black-	T.White-	Phthalo Blue-	Hansa Yellow- Nap. Red Light

Red Violet is the coolest color in the beginning Paint It Simply palette. Many think that blacks are the coolest. This is not true. Some blacks are even warm. Our Carbon Black is considered a neutral leaning cool. White is a Neutral color.

Many also think that Phthalo Blue is cool. This is not true. Ultramarine Blue and Phthalo Blue are warm colors. There is not a manufacturer today of a cool Ultramarine Blue. However, blues will appear cool when you use them in association with warmer colors. For example, look above. Then Phthalo Blue is slightly warm of neutral. According to the scale, it is cooler than the Naphthol Red Light. So, if both are used in a painting, the Phthalo Blue will look cool and the Naphthol Red Light will look warm. The human eye is constantly balancing colors. You may see the blue as cool in a painting, but it only appears that way based on the colors that surround it. Trust the scale above and you can paint temperature in any Paint It Simply lesson.

Brightness or Intensity in a color is also referred to as Saturation. There is a scale for this brightness that is used by companies to establish a language of color. For Paint It Simply, we need to understand a just few principles. In the tonal lesson we learned that any tertiary color (or grey) will tone a color. Any tertiary will work. Also, we want to create harmony within our painting. Harmony is when all the colors

go together. When we use a common toner to adjust the brightness of a color, we also increase the harmony between the colors. This is a benefit of using a limited palette.

Lets look at some color. In this example, I mixed Brown (2 parts red to 1 part black). The top line is Hansa Yellow mixed with Brown. The intensity (or saturation) of the yellow is reduced as it moves from left to right. Next, I made green with Hansa Yellow and a touch of Phthalo Blue. By slowly adding Brown, the intensity reduces from left to right. Both colors have harmony because I am toning with the same color so they "go" together. In this case, Brown is our common toner.

The next example shows the "grey" method of toning. Greys and blacks are added to Hansa Yellow to lower the intensity. However, you can see that Yellow turns green with the addition of Black. Adding small touches of Red will bring the Yellow back to a Toned Yellow. Blacks are wonderful to tone with and do add harmony. Sometimes, they change the "hue" or color, as in this case, yellow becomes green. Using tertiary colors can lower the intensity while maintaining the same hue.

The Colors of Burnt Sienna and Pine Green

Burnt Sienna is a pure pigment and is an the earth color. A burnt orange color, it is extremely warm in temperature. Think of it as a toned orange and you can predict mixing results with ease. Mixing Burnt Sienna with Hansa Yellow (shown on the left) yields a wide range of toned yellows. At the top, the yellow mixes are cooled with a tiny touch of Black or a little Red Violet as shown at the bottom. Adding a touch of Black to the Burnt Sienna alone will give you beautiful umbers. Add a touch of Blue for soft greys when lightened with White. You can make endless color combinations!

Pine Green is not a pure color but rather mixed from many pigments. Some artists have trouble mixing greens so it is a great shortcut. Pine Green is a warm color. (See the example above from left to right.) Add Hansa Yellow for bright yellow greens. Add a touch of Phthalo Blue for intense teal and blue greens. Tone with Burnt Sienna to make brown greens. Mix with Red Violet for cool darks. Add Black for deep

dark greens. It is a powerful benchmark green for your limited palette.

Rendering Your Images- Your Own Style of Rosemaling

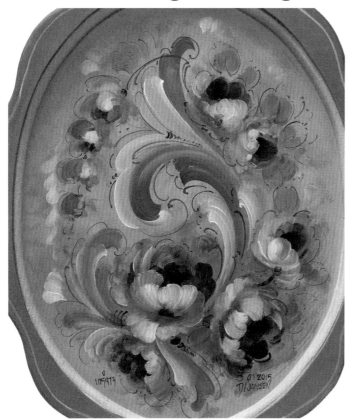
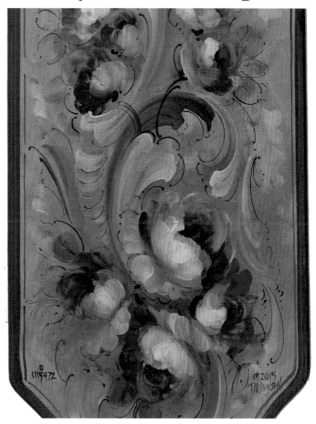

Here are 2 paintings from this packet and my thought process that goes with them. When I first started Rosemaling in the 1970's, I followed my teachers very closely. I copied everything they taught me and then repeated it. Through the 80's and 90's I studied the history of Rosemaling, design periods and how the styles changed over time. I never put the creation process and design periods together until I reread my first Rosemaling book by Sigmund Aarseth. He states that society is not static so neither should be the Rosemaler. A style needs to grow and change, because if it doesn't, it will die. Powerful words. So, I returned to history to find how artists changed the styles. Now I follow their guide. I take modern flowers and incorporate them into the scrolls. Relax the edges and explore new techniques.

Creating a Vignetted Painting

To vignette a painting is to allow the colors to show some of the original background. I have read many rules over the years such as: 20% of the painting must be the white of the canvas. I don't know if I truly agree with that, but it is a place to start. Normally the artist chooses a focal point and will contrast it with a color on the background. Then you soften that expression as the color heads away from the center of interest. In this example, notice how the blue contrasts the head of the chickadee and then softens, even with strokes, to the white background. You can add other colors as needed. It is an artistic look that I truly love exploring. I am going to do more of them!

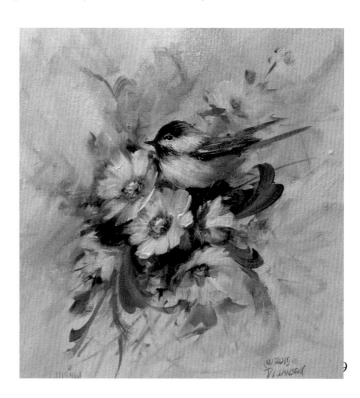

Rendering the Lost Edge

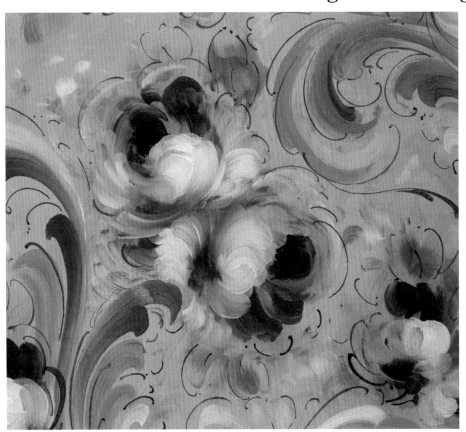

What makes a painting different from a photo? Painting represents the brush and how we use the brush defines the type of artist we are. Every artist uses a brush differently. That is what makes the painting so unique and individual. To render the painting realistically, there are techniques we use to define the edges of the painting. These techniques support the details you would see in real life. Artists, however, create interest and depth of field in the painting. What we see happen over a long distance, the artist compresses into a small area. This effect is enhanced by what we call the lost edge. Lost edges develop the depth of field in the painting.

When I was a decorative painter, I would transfer the design and then fill in the design with color, making sure I followed the design exactly. This precise line from the pattern always left a hard edge of color in my paintings. However, we need to control the hard edges to increase interest and depth in our paintings. As an object recedes in nature, the human eye loses the ability to see the edges clearly. Detail diminish and the edges become softer. It is like looking at a mountain in the distance. You can't see all the trees that are on that mountain, but they are there.

Rosemaling is normally done with many found edges, but recently I have been creating new styles that use lost edges for enhanced interest. This is especially evident in the main flowers of the focal area.

Brushes for Wet in Wet Edge Techniques

When deciding on the brushes to use, I think about the types of edges that the brushes will give my painting as well as details. The type of edges you will look for depends on the plan you have developed for the painting. In these lessons, I want detailed strokes in the center of interest and as softer edges further out. This gives the flowers more contrast and draws the viewer's eye to that area of the painting.

I break brushes in to types of details they give the strokes. I use a Raphael 16684 #3 quill any time I want very fine details. It makes very small additions of colors. However, it doesn't make soft edges so I use it where I precise lines around scrolls and flowers.

The Global Art # 4 or # 8 watercolor round is one of my favorite brushes for painting lines. It makes both soft and hard edges depending on how you use it and the consistency of the paint.

I also use the Global Art fusion flats and filberts in various sizes. They don't make as fine an edge as the rounds or liners so I use them to establish the movement of the color. Sometimes I load the corner or chisel to give more found edges to flowers and scrolls.

Pulling Scrolls and Strokes

The scroll has two parts that we need to concern ourselves with. The knob and the tail. The knob is painted with the flat of the brush and the tail with the chisel of the brush.

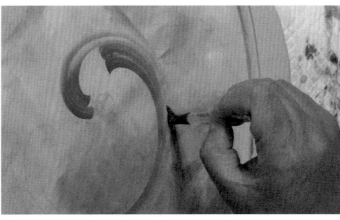

You can use a flat or filbert. Scrolls can be pulled toward you or away from you. Especially if your painting casually. Move the brush from the flat to the chisel of the brush which forms the tail.

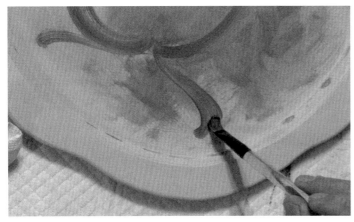

Sometime pull in the reverse direction- from the chisel to the flat at the end of the scroll as shown in the last photos here. This isn't Rosemaling with defined directions.

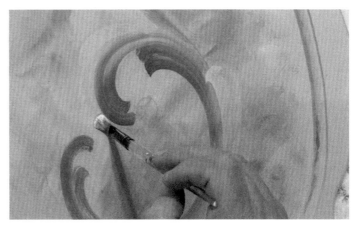

These are casual acanthus scroll that are decorated with additional strokes to make them look lighter and airy. Change the colors and adjust the pressure on the brush so they look different.

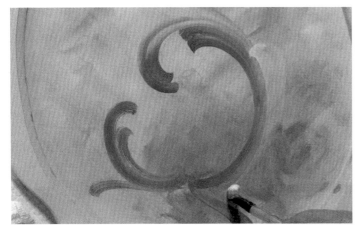

Pull them in all directions. The key to beautiful scrolls is to keep them simple and the brush constantly moving. Never press the brush down too fast or you will lose control of the scroll.

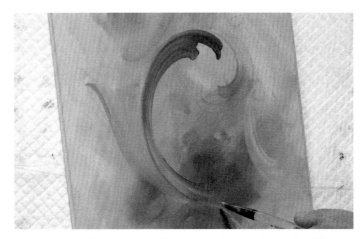

If you want larger scrolls, use a larger brush. If you press too hard on the brush, then it is difficult to find the chisel as you round the scroll heading to the tail.

Consistency of the Heritage Paints

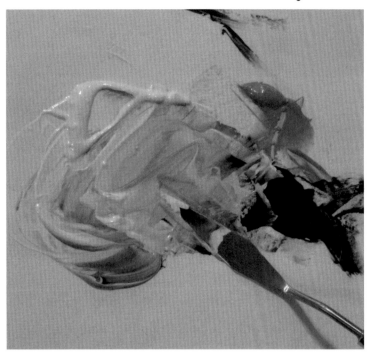

Notice The thick paint and how it does not "run" together on the palette. It "flows" around but keeps its consistency

The Heritage Acrylics are thick bodied acrylics designed for professional artist painting. You can do a variety of techniques with the colors which we will introduce you to in this book.

Acrylic Painters

Today, many acrylic painters in the decorative painting industry are accustomed to using low quality bottled acrylics and "flow" acrylics that are meant to be thin. Many acrylics used in decorative painting are designed for stroking and simple painting techniques.

Paint companies thin the acrylics to make them flow better. Because of this, if you have painted with bottles or used "flow" acrylics, you are used to thin paint. This can present a problem when you paint the techniques in this book. You may have the tendency to apply the color too thinly. This causes the paint to dry too quickly and prevents you from developing the depth of color necessary to add the interest to the painting. Keep this in mind as you paint through the lessons. For these techniques I use very thick color!

Application of Paint

One of the most common issues in new painters is the fear of using paint. This fear causes a new artist to use less paint, apply thin color and try to stretch their mixes with water. Over the years, while developing these techniques, I noticed I was slowly applying thicker and thicker paint.

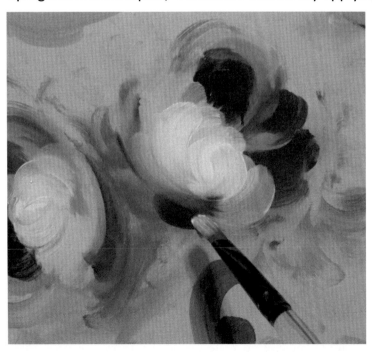

Paint must be used thick enough on the surface so you can use your finger to "push" it around and create the soft undertones for flowers.

John Singer Sargent, who was one of the greatest Alla Prima painters of the 19th century, said that an "artist should apply the paint so it flows together. " I studied his paintings in several museums in Europe and the USA. They looked so thick and fresh and had huge amounts of paint. But what did he mean by "flow" together? My first thought was paint has to be thin in order to flow together. Many paintings later, I realized that the paint must be thick enough so that it "moves" together but doesn't blend.

Thin paint "runs" together. Thicker paint moves together while keeping the color clarity intact. You want to be able to control the movement and the softness of the colors. To do this, you need thick paint. Lots and lots of thick paint. That is the secret!

How Much Pressure to Use

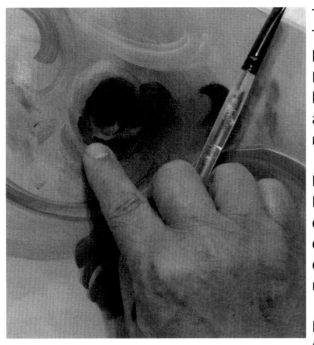

TTo help refine your technique you must learn the paint. This is one reason why I have always been an artist of one brand of paint. I learn the paint to learn new techniques. If you really want to excel at a given technique, pick one brand and stay with it. Each brand has different properties and control characteristics. To create beautiful effects, you must completely understand those characteristics.

For the past several years I have used Heritage Acrylics. Heritage Acrylics have amazed me in the ability to create different looks with different pressures on the brush. This depends on the consistency of the paint and how much is on the surface. Understand how the paint is drying and refine your techniques as the paint sets up and dries.

For example, I work the entire painting design at the same time. This lets the paint tack as I work in different areas. How much pressure to use on the finger or brush depends on how tacky the paint is. This will only come from practice with one brand. I like the paint to be a little tacky before I create lost edges with my finger. I like to push thick tacky paint. It takes more pressure to do this and thus I have more control than if using wet thin paint. I can use soft pressure for a little blending and press harder for more. Pressure is the key.

Tacking Heritage Paint- Optional Technique

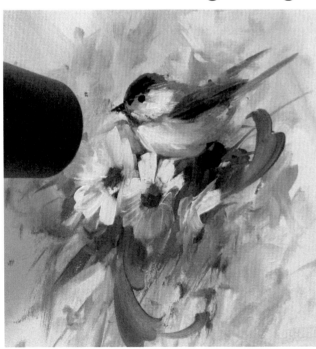

One technique I have been using a lot lately is to tack the Heritage paint with a hairdryer before working more layers. The advantage to this is that you can place additional layers of color on top of the tacked surface without causing any blending or pull up of the color underneath. It is a more controlled way to paint.

General Technique
First start your painting. Interest comes from color depth so the more paint you apply, the more interest you develop. This is the general principle of art and has been used by artists from Rembrandt to Sargent. However as you apply more paint, the next layers begin to pick up the colors under them making it difficult to control. It is a problem with wet on wet painting. What I do now is to "tack" the colors when the paint starts to get a little too thick. Do not dry, just tack. Warm air not hot. Just for a few minutes. This will cause the paint to thicken slightly and become a little "sticky". Then apply more layers of color. I use my finger to "push" the colors together. The wet color on top slowly works into the stickier paint underneath. This gives you more control. Whenever you feel your colors are blending too much as you apply strokes, tack the colors and it will not happen. Not too much, just a bit.

13

Additional Techniques Used In Paint It Simply Techniques

Brush Mottling

This is a technique we use extensively in this book. To create a mottled brush you need to have colors about the same consistency. Place the colors right next to each other on the palette. Tap the brush up and down on the palette to load into the brush. Do not stroke the brush on the surface of the palette because this will cause them to blend and soften. Tap the colors on the palette just enough to cause them to load into the tip of the brush. Apply the colors to the flower or blossom with a light tapping motion. Use a very light pressure on the brush so that the tapping doesn't continue to blend the colors. A great technique for interest in the flowers.

Pushing Color

I love the casual look that is created with the fingers. Apply color to the surface. Mottle several colors. Pushing color works the best if the background is wet with thick paint. Most techniques require thicker paint so make sure you have it on the surface. Apply the paint with the fusion brush. Then, using good pressure with your finger, push the paint around into the shape of the object you are painting. I love to do this technique on the fronts of roses, where you want the colors to mottle and swirl, but not to blend. Too much brushwork can blend the color where pushing them around with your finger preserves the color.

Blur Objects for Depth

This is a technique that is very important to the lessons in this book. Here we will start large areas of color. Do not paint each object perfectly. We leave edges undefined. I describe this to students in this way.... We start the painting like we are looking through a camera that has not focused on the subject. Do not find the edges.... Move colors and strokes around without finding perfect shapes. Think of it as slowly turning the focus ring on your camera, bringing it into focus. This will help develop tremendous depth in your painting. Start soft and undefined. Slowly add more edges to object.

Lost Edge of the Petal

Artists are painters of edges. We fill in pattern lines or paint objects with edges that give them form and structure. The edges though are very important for dimension within the painting.

In real life, the human eye can not see all the details in objects that are far away. Edges of the objects "blur" as you get farther away from them. Our eyes are used to seeing this concept everyday. To capture this visual depth, the artist will paint a very clear edge to objects that they want to come forward such as the front petal of a flower. They will soften or blur the back ones so they recede. I use my finger for this. Softening the edges of objects that are not important brings forward the others.

Additional Techniques Used In Paint It Simply Techniques

Optical Blending
This is a concept made famous by the Impressionist painters of the late 19th century. With this, the artist leaves portions of the painting "unblended" allowing the viewers eye to blend the tones from a short distance. Usually the artists take a step back of about 3 feet to view the painting. This softens the effect. The photographic cameras usually soften the effects of a photo. When artists paint from that photo, the result is an overblended painting. To combat this, we leave more areas of color exchanges. Try not to stroke more than 3 times in any area. Do not stroke many times! Leave streaks.

Lifting Off
Many times we paint the object with layers of color. With most decorative techniques with add colors that are needed to the object. With lifting off, you paint, then cover it, then lift the second color off revealing the first color. I love this technique and it is one of my favorites to use on rose shadows.
Apply base color. Then apply the shadow as needed on the object. For example at the bottom of the bowl. Then apply the mid value and highlight as desired. Many times you need to reapply or "restate" the shadow because we lose it. But, with the fusion brush, and sometimes your finger, you can start at the shadow and push up to lift off some of the base color and highlight, revealing the shadow again. Variation!!!

Flow Texture
The secret to a successful painting is paint. We say in the Program.."It is easier to paint with paint!" This is so true. When painting the lessons you need to use a lot of paint and use it fast.
One of the greatest painters during the 19th century said that the artist should use paint so thick that is flows together, rather than mixing. This is the technique! Do not mix, let the color "swirl" and flow together, then optical blending will soften the colors when view from a short distance.

Corner Detailing
Although I did not use this for the centers in this packet, this technique can be used to add more interest to the centers of the roses and other areas if desired. With the fusion flat or filbert brush, we use the corner of the brush to create edges and add the small details. The corner of the flat / filbert does not make the details as perfect as a round brush so it is perfect for this look. Pick up thick paint on the corner of the brush, use different pressures of the brush to make different effects. I usually like to mottle the color on the palette, then corner the flat / filbert with the mottled color before detailing.

Additional Techniques Used In Paint It Simply Techniques

Transparent Color Washes- Sketching Shapes

Throughout the lessons we will add lots of interest through the use of color washes and creating a mosaic of colors. Artists for hundreds of years have concentrated on paint consistencies to enhance the designs.

With these lesson you will see several times where you should add various colors into the background and also within the petals. This is called a "mosaic" of color. When you apply this mosaic of color please vary the consistency of the paint by thinning some colors with additional Extender Medium. Varying the consistency of the colors will increase the variation within the blossoms.

The basic control or soft blending that occurs as you move the brush around the surface is controlled by the paint consistency. If a certain lesson is not working, I highly suggest changing the consistency of the paint for a better result.

Light Color Petal Edging

One area that the fusion brush excels is in the application of white edges and then softening them with other strokes. Throughout the lessons, we will edge the brush with various Whites, and then use the brush to "draw" the petal before filling it in with color.

To do this technique, tap one edge of the brush into the White or suggested light color. Sometimes I use the chisel edge, flat edge or at an angle as shown in this photo. Wiggle the brush as you draw the outside edge of the petal. Varying the amount of paint will create different petal effect. Once I have drawn the outside edge of the petal, I then stroke the brush back and forth to fill in the petal with color. If anything gets too harsh or too much, I soften with my finger.

Negative Painting

In this technique, you use the background colors, or in this case the greens from the leaves to clean up the edges of the roses, especially in the center area, rather than applying the edges again to the object.

This technique works very well when you are working on a wet background. Paint the desired object. Sometimes I will paint the object, a petal for example, then wipe my finger over the petal to soften and carry some background color into the petal. Then come back with a slightly larger brush with background in it and paint the background which will clean up the edge of the object. This also makes the object look more transparent. When painting, you can make edges with the objects color, and also in the reverse with the background. Negative painting in another great technique to add interest.

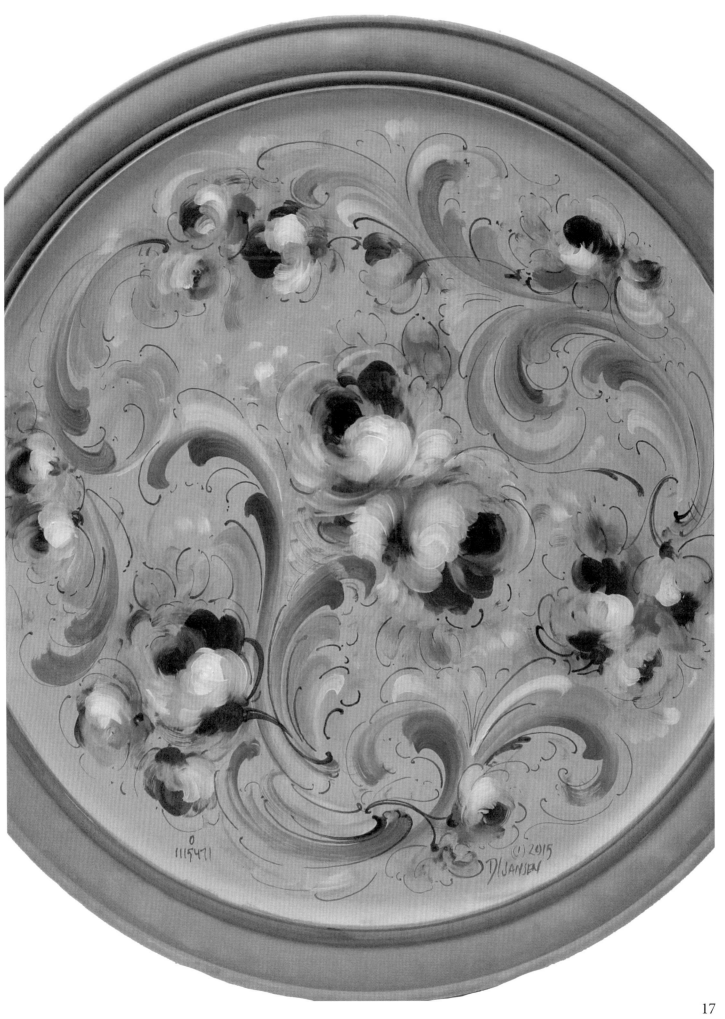

Telemark Inspiration- A Few Thoughts

One of my influential Rosemaling teachers said that society is not static so the artist should not be. Rosemaling needs to expand and grow. New looks and expressions need to be developed to keep it fresh and exciting. I am trying to follow his advice. I love the history and styles of Rosemaling. As I studied the history, I realize that many artists have changed the styles over the years. This is also why we are blessed to have so many different variations of Rosemaling. Never be afraid to experiment. This is how art grows.

Here are 3 lessons which use the same techniques and processes. You can use any of the techniques described in the front of this packet to help you build your design. Explore and try new things.

One helpful technique is the Heritage Tacking Technique. Even though I didn't use it on these designs, I use it a lot in painting today. Building strokes of color can be difficult if you get too thick of paint down on the surface. It is tricky to find the correct amount. Not enough color and there are no lost edges and interest. Too much paint and the stroke is immediately lost. If you get too much, don't worry, just tack the scrolls and flowers. I paint around the entire design at one time. This give time for the areas to dry slightly. But use a hairdryer if you need. Let's give it a try!

Paint It Simply Palette
Base Color Plate- Medium White
Base Color Plaque- Medium White + equal amount Light Grey
Base Color Scalloped Tray- Medium White + equal amount Light Grey

Palette Colors

Paint It Simply Colors	**Additional Palette Colors**
Naphthol Red Light	Pine Green
Red Violet	Burnt Sienna
Carbon Black	Yellow Oxide
Phthalo Blue	
Hansa Yellow	
Titanium White	

Wood Surface
Lesson 1- 20 Inch double beaded narrow rim plate- JansenArtStore.com
Lesson 2- 9 X 19 Inch Oval Plaque- JansenArtStore.com
Lesson 3- 17 X 13 1/2 Inch Oval Scalloped Tray- JansenArtStore.com

Step 1 Base coat the plate Medium White, dry, sand lightly with 180 grit sandpaper and then transfer or sketch on the design as shown above.

Step 2 Using your palette knife, mix together some white with touch Yellow Oxide and Carbon Black. I will make a light grey color and the yellow will give just a little warmth.

Step 3 Using the 3/4 inch brush add some Extender Medium and go over the plate with the light grey. Not too thick and mottle on surface so some Medium White shows through.

Step 4 I used a paper towel to wipe off the excess so you can see your pattern through the light grey.

19

Step 5 Mottle Naphthol Red Light with touch Red Violet to make a nice Christmas red color.

Step 6 Casually dance the brush around where the flowers are going to be. Just apply some color. Do not worry about the pattern. Make the splashes of color larger than the flowers.

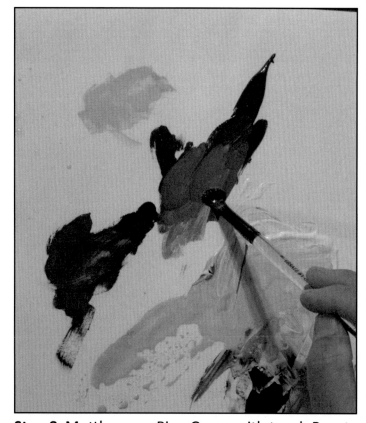

Step 7 Using your hand, blur the edges of the reds we just applied to soften them into the background. This creates the lost edges for the flowers.

Step 8 Mottle some Pine Green with touch Burnt Sienna which will keep it warm and tone. Not too much Burnt Sienna. Lighten with touch white.

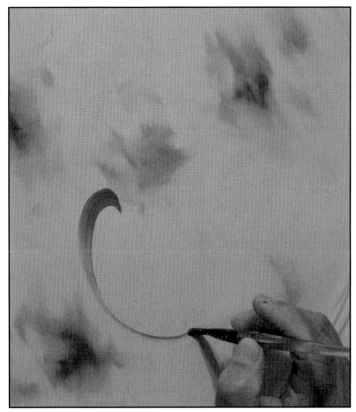

Step 9 Begin the main C scroll with the flat of the filbert pulling in a graceful arch to the chisel of the brush which makes the other end of the scroll.

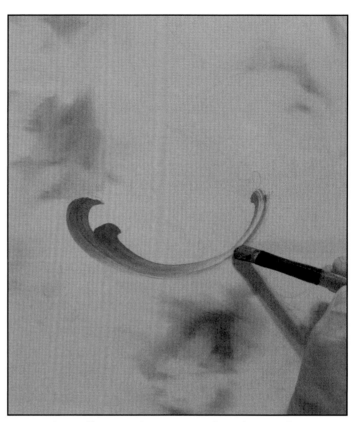

Step 10 I will sometimes turn the plate sideways to pull the next scrolls. This keeps them a little different from each other making it more casual and not as perfect.

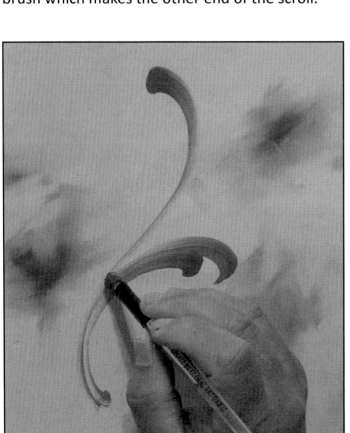

Step 11 Start the long S scroll like the C scroll on the flat of the filbert and pulling to the chisel to move the lines together.

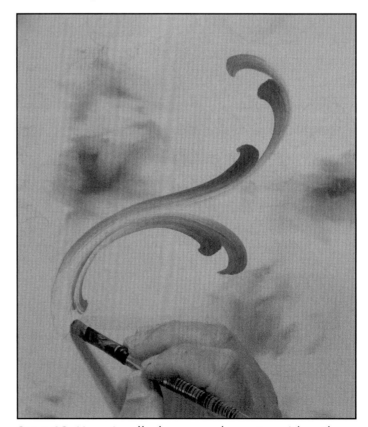

Step 12 Here I pulled a second one to widen the first and then use the chisel to draw down to make a wider C scroll. This makes the scroll look transparent.

21

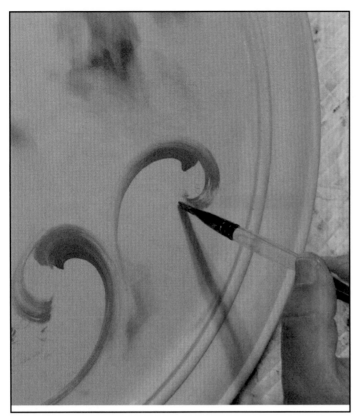

Step 13 As shown in the front of this packet, sometimes I will pull the scroll from the chisel to the flat to give a different look. This is very important for the casual nature of the painting.

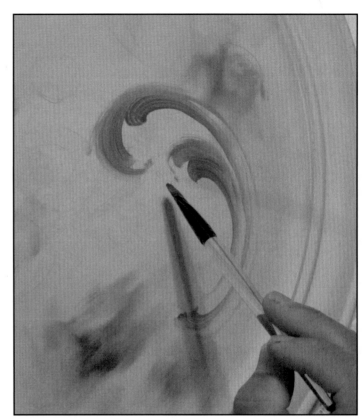

Step 14 Add some wispy ends to the scrolls to make them more casual and create some lost edges.

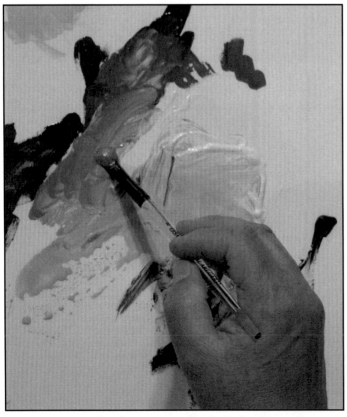

Step 15 Mottle the color a little lighters and go over some scrolls to change the colors a little. Variation is the key to interest and we need to show variation.

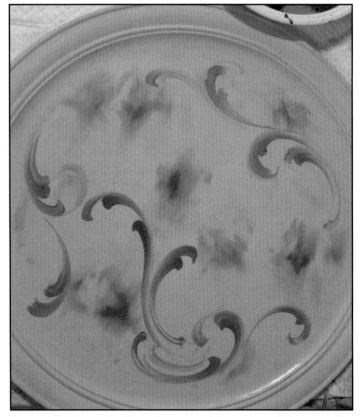

Step 16 Here is the plate to this point. The scrolls give the movement and the flowers are ready for some decoration.

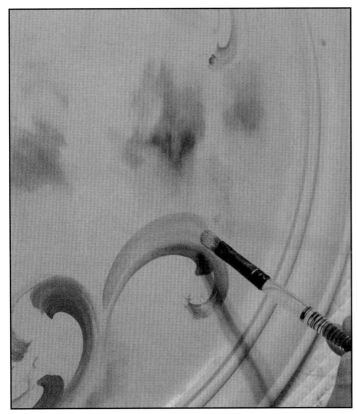

Step 17 Mottle the color a little lighter with more white and begin to thicken the scrolls with strokes to the back and inside.

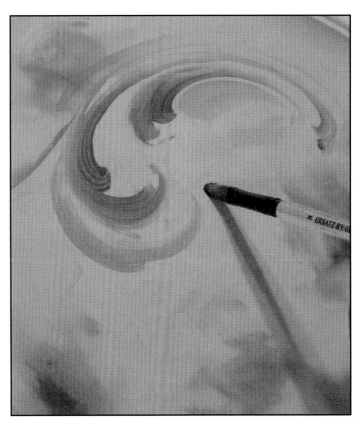

Step 18 Leaves some air spaces between the scrolls. This make them fell more "airy" and lighter in the design.

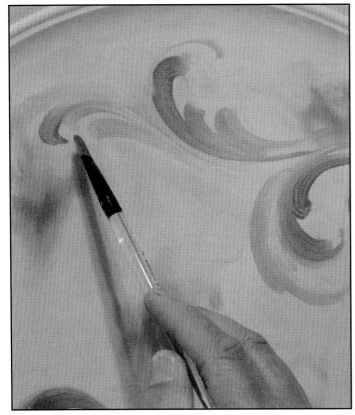

Step 19 I will stroke these very casually, even sideways to keep them from becoming too stiff.

Step 20 Begin the flowers with the mottle reds and make a darker small center or the rose stroking out so the color fades into the background.

Step 21 Pull some strokes across the rose from one side. Let the colors fade into the wet background. If your background is not wet, give a light coat again in the area of the roses.

Step 22 Notice all the color variations. This is from the mottled reds and the colors fading into the background. This is the key when painting a limited palette like this.

Step 23 Use your finger to soften some of the edges on the outside roses. We want more interest in the center.

Step 24 Mottle the greens a little lighter, I added some Hansa which will make the greens really "pop" with the reds.

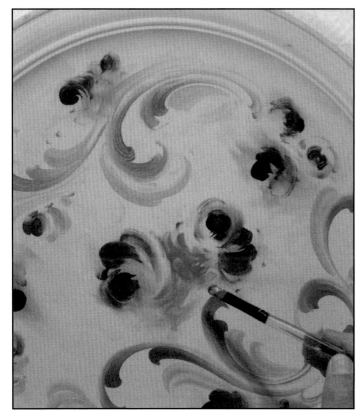

Step 25 Casually add some of the greens between the roses and let the colors soften into the background as you go out.

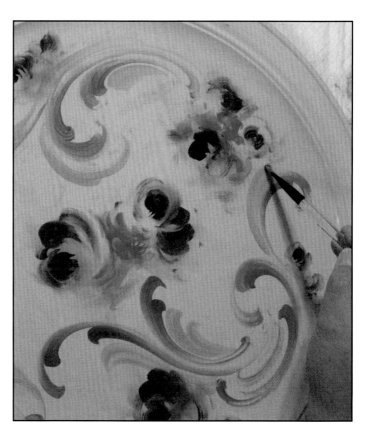

Step 26 Add some wispy strokes of the lighter green to the flower out and around the rim of the plate.

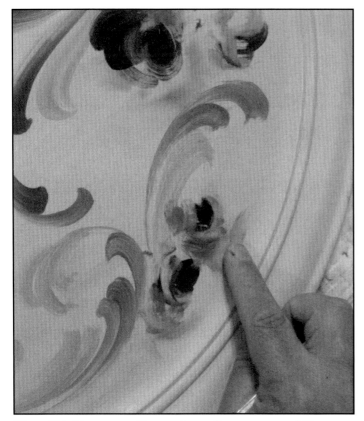

Step 27 Use your finger to soften some of the edges of the greens. I even let some of the greens and reds run together. It looks great!

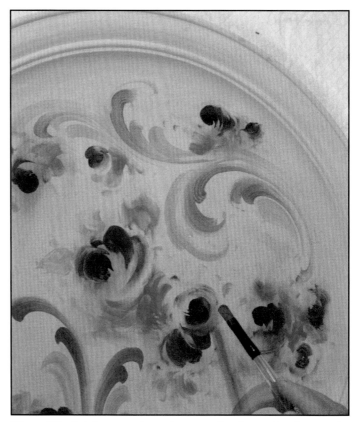

Step 28 Add some touches and wispy strokes out away from the center of interest. This make the design more "airy".

Step 29 Mottle Yellow Oxide and white together to make a lighter yellow. Yellow Oxide is a very opaque pigment. Great for Rosemaling.

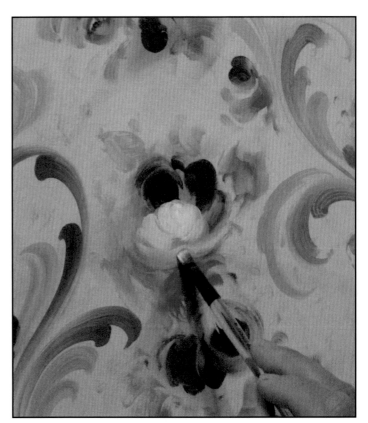

Step 30 Build the front of the roses with this color. The center petals, stroke in both directions so they appear round. Let the colors soften and fade as you go around the rose.

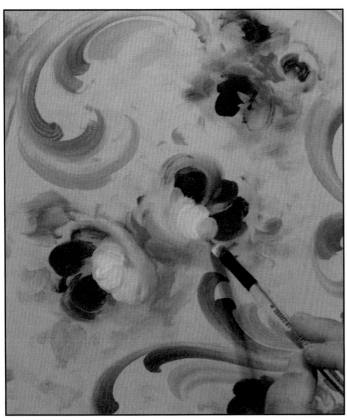

Step 31 Try to make the centers different on all the roses. Here I will stroke heavy in one direction so the rose looks different than the other one in the center. See final photos.

26

Step 32 Here I pull a curved stroke across the bottom of the rose to make sure the bowl stays round. For this stroke I used some mottle Red Violet since the color is cool.

Step 33 Add some additional strokes of the mottled Red Violet to the bottom of the roses to create a bowl. We will add reaching petals soon.

Step 34 Soften some of the Red Violet into the rose with some light strokes of color.

Step 35 Lighten the front color of the rose with more white and then add some strokes pulling in to the bowl. This creates the reaching petals. Let soften as you go around the rose.

Step 36 As you stroke, move up the side so you create small strokes. This will give interest. Not too far apart though or it will distract from the center of the rose.

Step 37 Use wispy stroke on the sides of the other roses. This helps them become a little softer. For the outside rose buds, just add a stroke or two to the center area. Not too much interest.

Step 38 Use the lighter white to add some lighter stroke movements to the scrolls. This helps move the white around the design.

Step 39 Notice how the white strokes to the scrolls tie the movement together from the roses. Always look to this as a technique to help add harmony to your designs.

28

Step 40 I added a few cross strokes to the valley between the scrolls. This gives more power to the center stem area which supports the design.

Step 41 Corner the filbert with some white and add a few edges strokes to suggest some petals. I used the corner detail technique describe in the techniques section.

Step 42 For the details I made a toned dark green with Pine Green and some Burnt Sienna. Warm color. Use Raphael 16684 # 3 quill and begin the detail work. Use photos for ideas.

Step 43 Thin the color with some water so it flows nicely. Start with the main lines then add the smaller one. Step off the edges to make the objects more "airy".

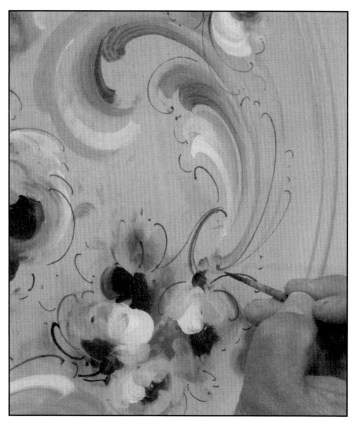

Step 44 Add the calyx to the bottoms of the roses and buds. Add some stem lines with 2 or 3 strokes to make them a little thicker.

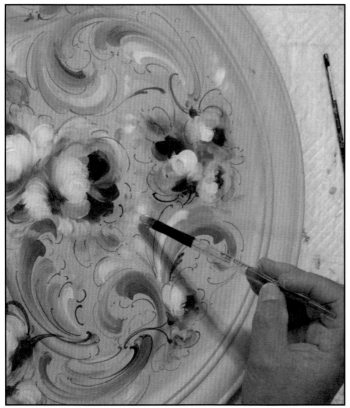

Step 45 After the line work I decided to lighten the design one more time with some accents strokes of white. These are casual wispy strokes which add to the airy feeling.

Step 46 Mottle the green, greys, yellows and touch reds to make a medium toned green or your choice. I use 3/4 inch brush.

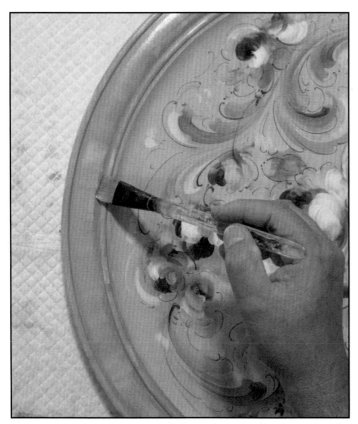

Step 47 Base the rim of the plate with the toned green, then while wet (use Extender if needed) go over with some short white strokes to mottle the rim. I stroke outside to inside.

Step 48 Mottle a toned red or even use red if your green base is still wet. Add the red trim to the beaded edge to finish the plate. Enjoy!

Telemark Plate Pattern. Enlarge 195% to Full Size. Pattern does not show lines for line work decoration.

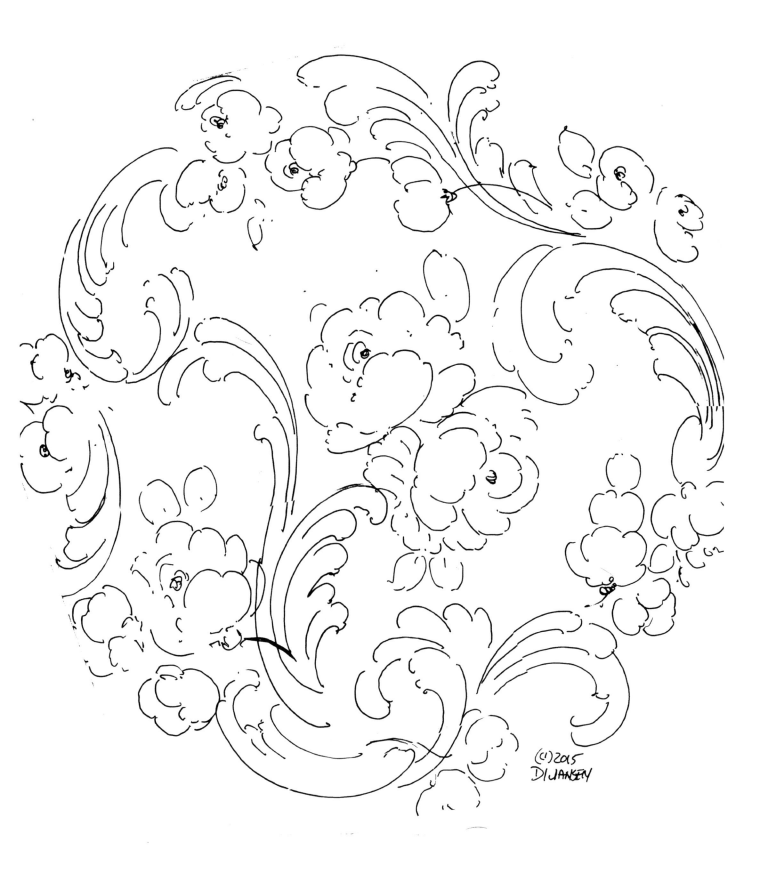

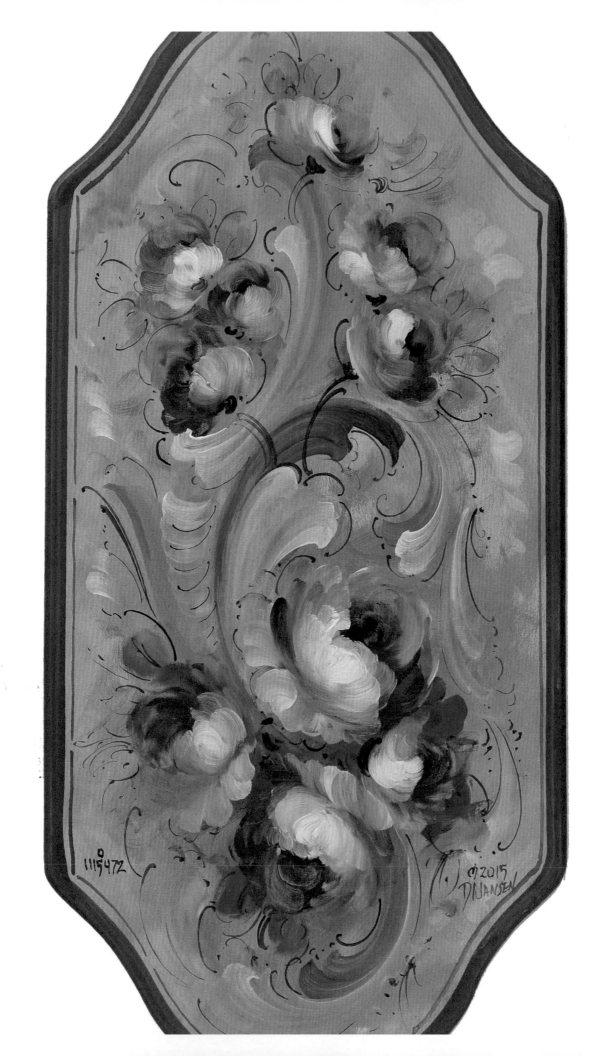

1115472 ©2015 DJANSEN

Step 1 Base the plaque with the light grey in the beginning of these lesson. Dry, sand lightly with 180 grit sandpaper and transfer or sketch your design. I didn't add any sealer to the base color.

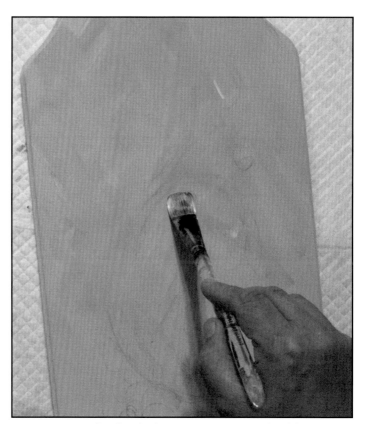

Step 2 Mottle the light grey again and add some Extender Medium. Go over the plaque with a light coat so we have something to paint into. Wipe off excess with paper towel if needed.

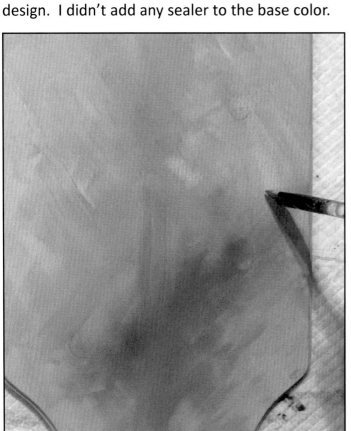

Step 3 Mottle the bottom of the plaque with some Pine Green and touch Black. This makes a darker green that will make the flower pop off later. Lighten as you go up.

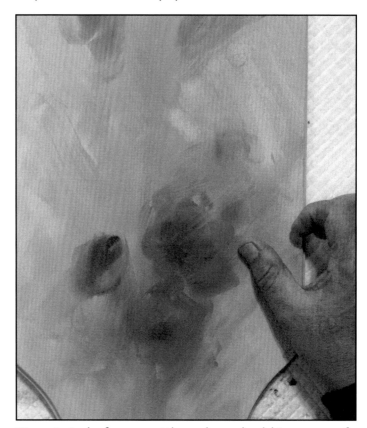

Step 4 As before, mottle reds and add in areas of the flowers. Soften the color into the wet background with your fingers to create lost edges.

33

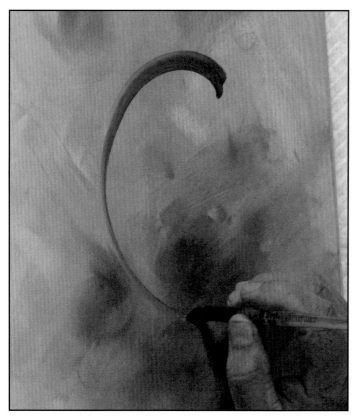

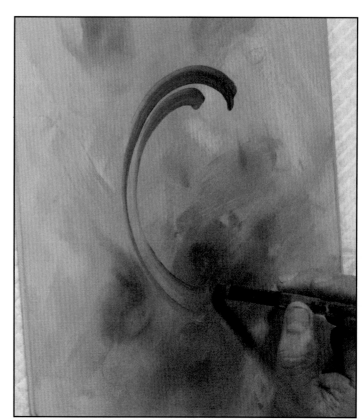

Step 5 Start the main scroll with some toned Pine Green. I used Burnt Sienna and touch white and yellow to soften slightly. Flat to chisel as you pull the nice C curve of the stroke.

Step 6 I added a second one to the inside, this time stepping off the side just a bit to widen the scroll and make a transparent center area.

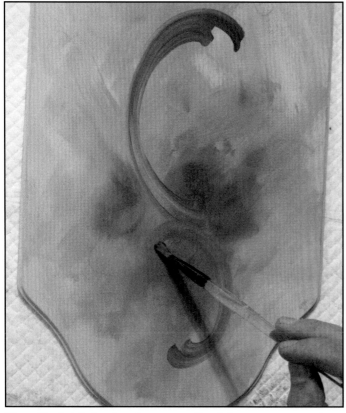

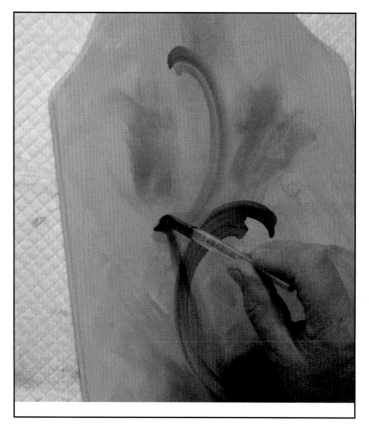

Step 7 Add the bottom scroll with reverse strokes so you have some interest in the stroke work. Do not always stroke the same.

Step 8 Add the top C scroll with slightly lighter and softer color. Build with 2 or 3 strokes letting the color run off so it is softer.

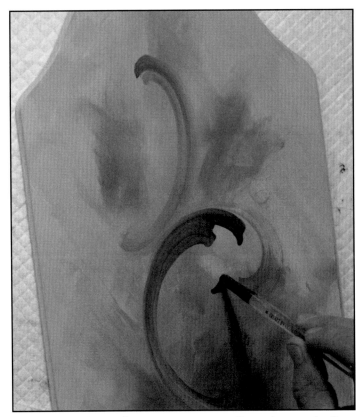

Step 9 Add a softer capping scroll to the end of the first scroll. We want to keep this soft because we want up and down movement in the design because of the shape of the plaque.

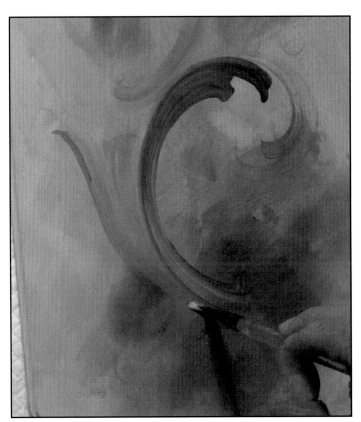

Step 10 Here I added a soft S scroll to the back of the main scroll. This subtly takes the viewers eye in another direction. Keep softer than main C.

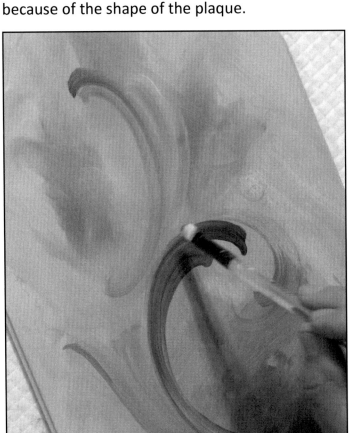

Step 11 Lighten the color with more grey and add some widening and filling strokes like we did on the plate.

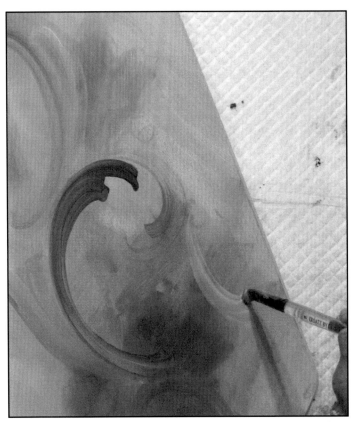

Step 12 Add some softer movement strokes off the cap of the main C scroll. Keep these light soft grey.

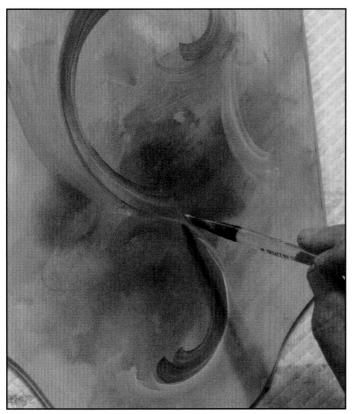

Step 13 Add a few strokes of the light grey to the inside of the main scroll. This helps to move color. Always think about the moving of color when Rosemaling.

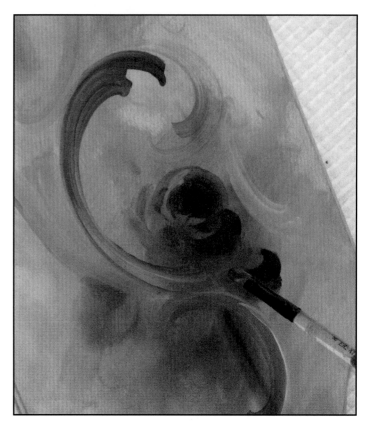

Step 14 Begin the shape of the roses with the mottle reds. Just like we did with the plate lesson. Stroke heavier to one side for variation and interest.

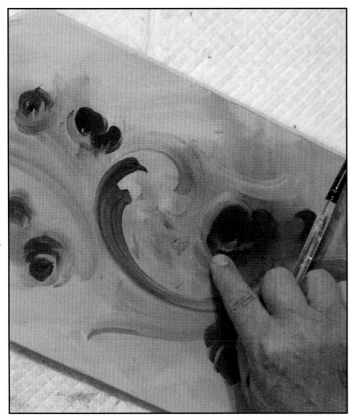

Step 15 Use your finger to push color around and soften the effects of the reds. This also incorporates the reds into the green background for more soft (lost) edges.

36

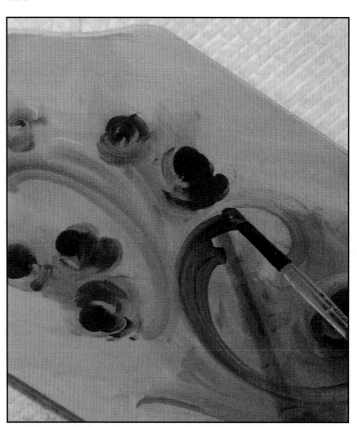

Step 16 Add as much contrast to the center as desired. I thought this looked good, but when I finished the painting, I soften reds with the last step shown in this lesson. A little too much.

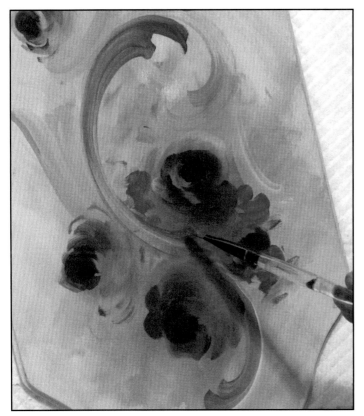

Step 17 Build the reds in the center. As I said in step 16, I think I added a little too much because I soften it with step 48. Add as much as you like though. You can always soften later.

Step 18 Mottle Pine Green and brighten with Hansa, add some bright greens between roses shown here and step 17. Keep causal movements of greens.

Step 19 I will even stroke some greens into the roses to carry colors and create wonderful color movement. Greens looks great in red roses.

Step 20 Mottle some Yellow Oxide and lighten with some white. Begin to build the front of the roses like we did with the plate lesson. Same technique.

Step 21 Add more yellow to the center front of the roses. Add as much as you like. I will soften this with some white later. Yellow makes a happy Christmas rose as well.

Step 22 Add some cool strokes of Red Violet to shadow the bottom of the bowl and set areas for the reaching petals of the rose.

Step 23 Lighten the color with some white and begin to stroke the center of the rose. Build the front up with as much contrast as you desire.

Step 24 Stroke out to the sides letting the color fade away to form the lost edges. Lost and found edges are new looks for Telemark and really give a lot of interest.

Step 25 Mottle with more white and begin the reaching petals. I over stroked this as shown in the next photo because I made it too "stroked" and than took away from the softness.

Step 26 Add a few strokes to the back of the rose to help close it off. This also carries the white around the back lighten the lifting the rose off the surface.

Step 27 Add shorter more light strokes inside the first strokes of the bowl. These will help make the rose look more round.

Step 28 Begin to stroke the fronts of the other roses. Build the colors. If it becomes too difficult use the Heritage "tacking" technique shown in the techniques section to help your strokes.

Step 29 Add some strokes of Red Violet to cool and restate the shadows to the bottom of the bowls.

Step 30 Build the reaching petals on the other flowers. Make sure they are not competing with the first one we painted. The rose on the inside main C is the dominate rose.

Step 31 Add some reaching petals to the other roses.

Step 32 Add some strokes of light colors to the fronts of the small rose buds at the top of the design. Keep them simple.

Step 33 I added a suggestion of some reaching petals to the larger ones at the bottom, but for most, just a center stroke of light color is enough.

Step 34 Carry the light color from the flowers onto the scrolls like we did with the plate lesson. This helps move colors between the flowers.

Step 35 Add casual strokes of the white down the sides. Also note how I let the brush skip and dance over the surface creating other shapes. Keep it casual.

Step 36 Add some light strokes to the inside of the main C. This carries color and also widens the power of the main C.

Step 37 Lighten some of the reaching petals on the main rose to make them more powerful now that we lightened the scrolls.

Step 38 Add some strokes between the main C and S. This makes the cornucopia shape that was very popular in many Rosemaling styles. Just casual!

Step 39 Add more lights to the inside of the other scrolls as we have done in the earlier ones.

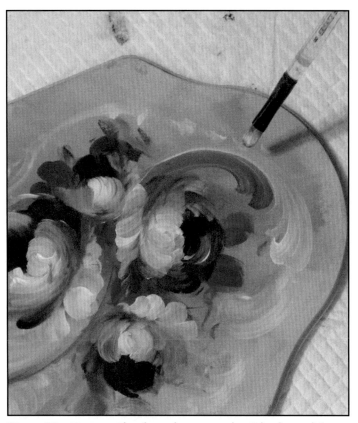

Step 40 Dance the brush around with the white to lighten the feeling of the painting and to carry the white around the design.

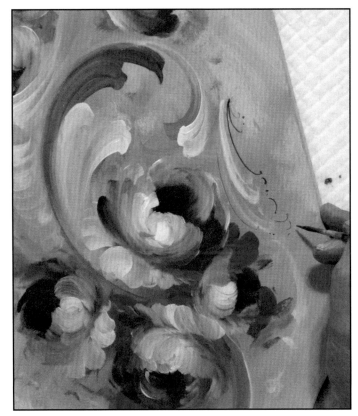

Step 41 Make a toned dark green. I used the same as the plate, Burnt Sienna in the Pine Green to warm and tone it. Using the quill, begin the line work stepping off the edges.

Step 42 The lines really help make the design feel lighter and more "airy". Take your time. I don't always follow the shape exactly. Use photos for suggestions.

Step 43 Make 2 or 3 strokes when you are adding a stem. I like 2 or 3 strokes rather than 1 thicker stroke. It keeps a lighter feeling.

Step 44 Lighten the front of the roses. I felt because I was using a lot of white in the scrolls, I needed to lighten the roses.

Step 45 I returned to the Yellow Oxide and added a few strokes to the roses and scrolls. This increased the yellow in the design which I liked.

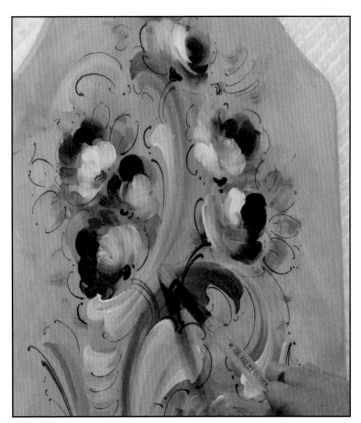

Step 46 I took a brave stroke right down the center of the scrolls. The scroll however had "tacked" so their wasn't too much blending which I liked. Move color, play, experiment!

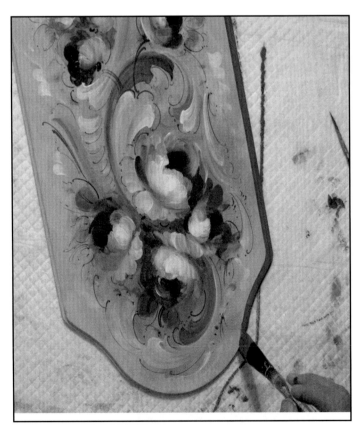

Step 47 Mottle a toned green from Pine and Burnt Sienna, yellows, etc. Add to the routed edge of the plaque, then add a stripe around the edge as shown in the photos.

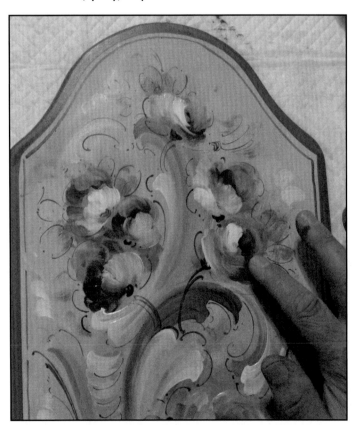

Step 48 I referred to this earlier. After I finished I felt the dark reds were too powerful a contrast in the roses, so I "removed" and softened the centers with a stroke of my finger.... Enjoy!

44

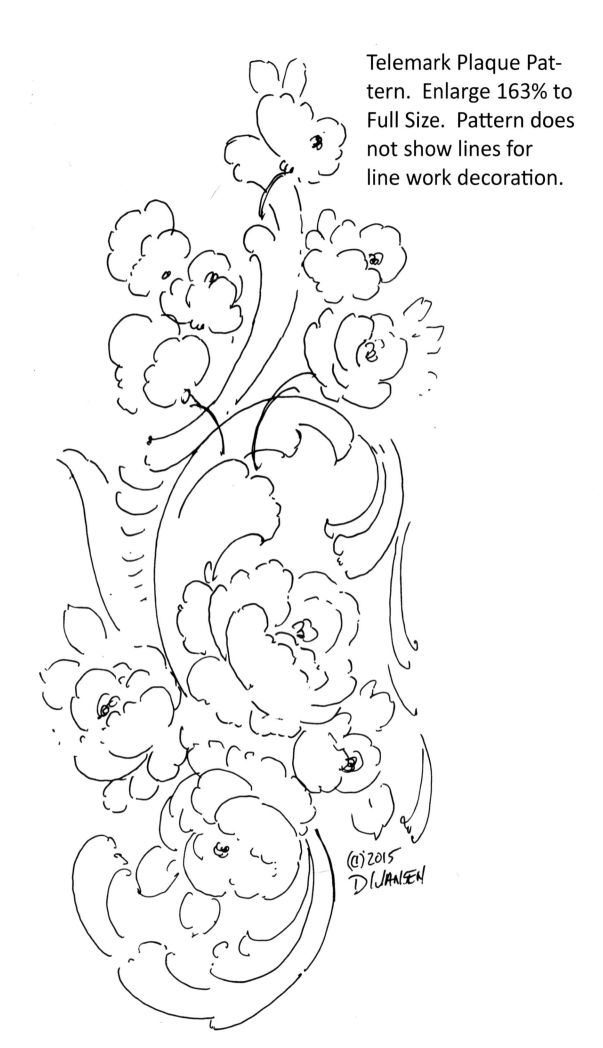

Telemark Plaque Pattern. Enlarge 163% to Full Size. Pattern does not show lines for line work decoration.

(c)2015
DJANSEN

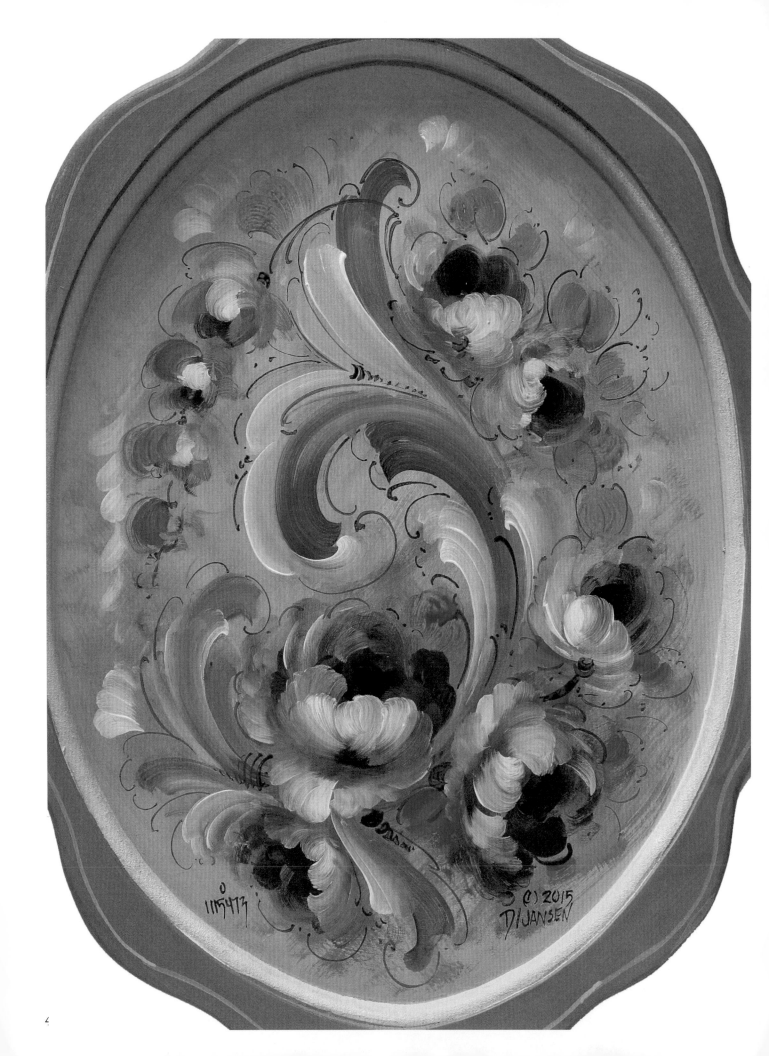

1115473

(c) 2015
D/JANSEN

Step 1 Base the tray the light grey, sand, transfer the design or sketch. Mottle Yellow Oxide and white at the top and then add a little toned Pine Green to the bottom of the design. Add Extender.

Step 2 I toned the Pine Green with some Burnt Sienna then lightened with touch white. After applying, lighten again with more white and go over the surface to soften the movement. Thin color.

Step 3 Mottle the reds and then casually apply to the areas of the flowers like we did with the plate lesson.

Step 4 Soften the colors into the wet background with your finger. This creates the lost edges of the flowers.

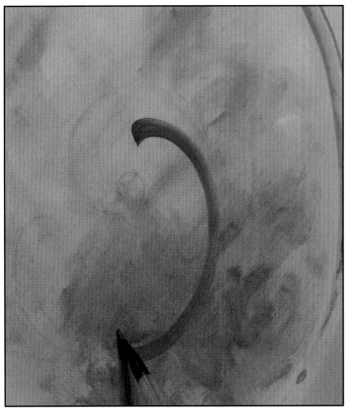

Step 5 Start the main scroll as we did before. This time however I kept the flat all the way down the C so the main root C has more width to it than the other ones. No chisel yet.

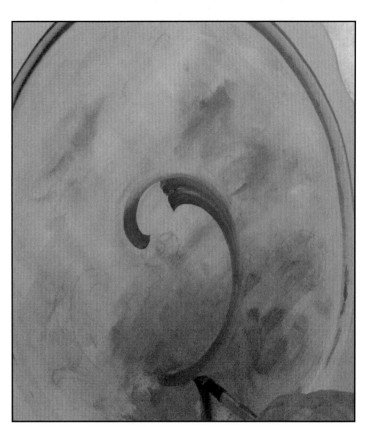

Step 6 With the next strokes, start on the flat and move to the chisel as you go down to blend the strokes together into the scroll shape. This makes the scroll wider at the top.

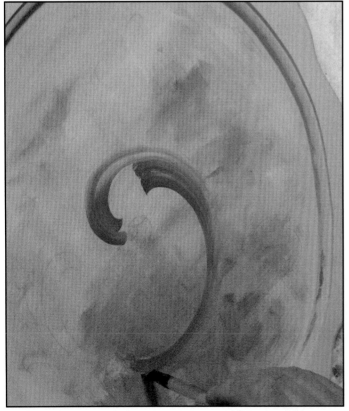

Step 7 Add a couple of stroke to the top cap of the scroll to build a more rounded shape. This fits the wider center part of the scalloped tray.

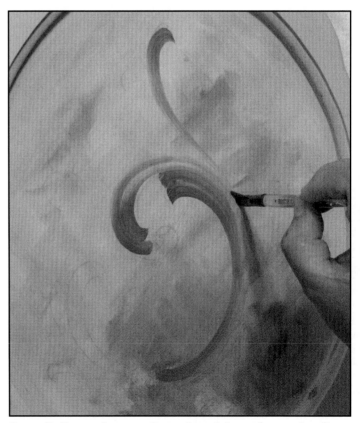

Step 8 Start the top S stroke. Move from the flat onto the chisel so you can blend the movements together.

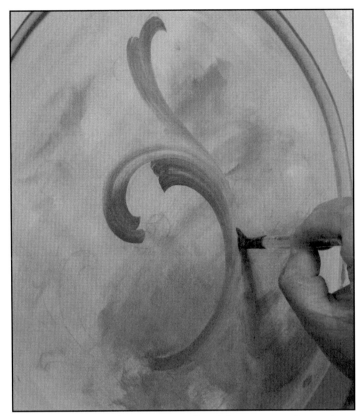

Step 9 Widen the top scroll with a second stroke to the back of the S scroll. Chisel into the first main root C.

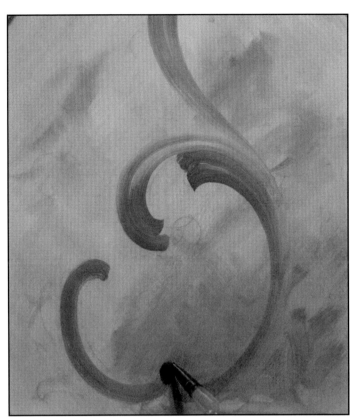

Step 10 Add a second smaller C scroll off the main root C keeping the brush flat to make the wider scroll.

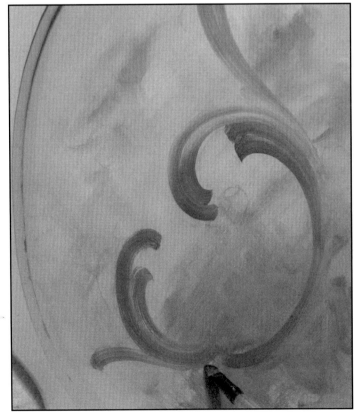

Step 11 Add a smaller inside stroke and then an S shaped outside stroke to create some movement. Chisel into first scroll to blend lines of movement.

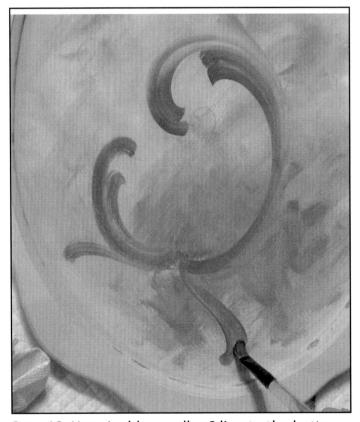

Step 12 Here I add a smaller S line to the bottom of the design. I widened the scroll with a second flat stroke to the back of the design.

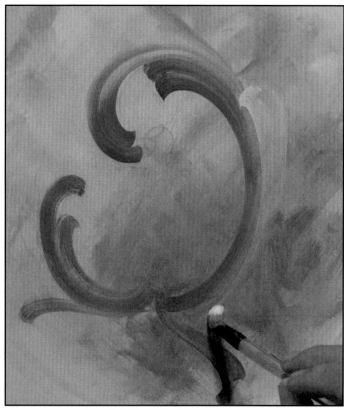

Step 13 Lighten the color with some white, touch black and white to make light grey like with did in earlier lessons and begin to decorate and widen the scrolls like other lesson.

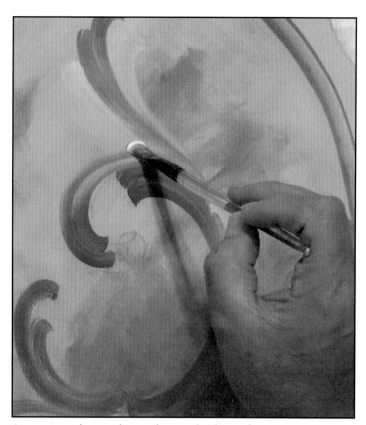

Step 14 I kept the colors a little soft at this time. I wanted to keep the power of movement to the green scrolls. Later though, I lightened them because I felt they were lost.

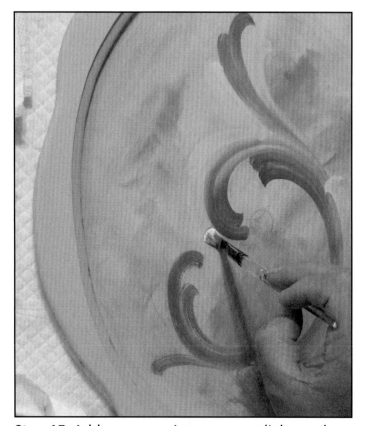

Step 15 Add some semi-transparent light strokes to the back of the cap scroll.

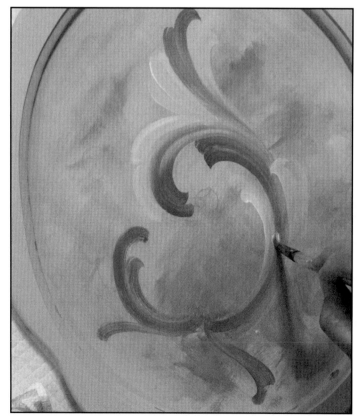

Step 16 I used the edging technique, page 16 to lighten the inside of the scrolls with more white.

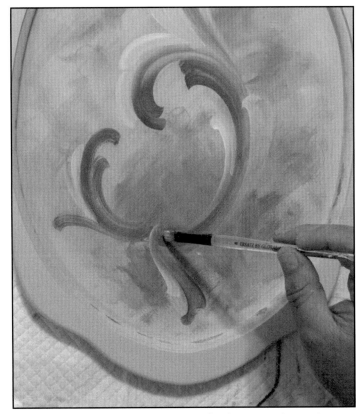

Step 17 Add some strokes of white to the other scrolls. This widens and gives good color movement.

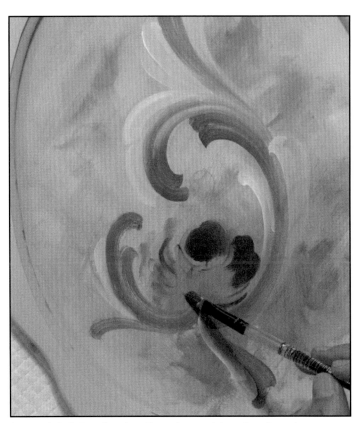

Step 18 Mottle the 2 reds and begin the shapes of the roses like we did with the other lessons. Build one side heavier.

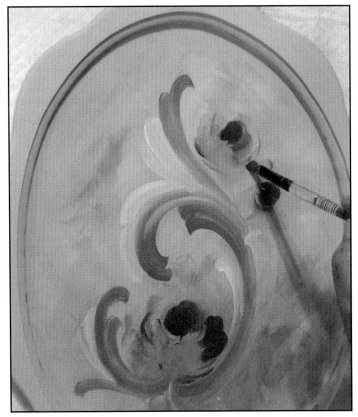

Step 19 Make the top rose buds smaller and less color than the bottom one. Keep reds mainly in center and one side, but use casually and dance brush around for color movement.

Step 20 Add the next roses with the same colors. Centers then dance the brush around.

Step 21 Here I am adding some up the side of the main C. Not as much red so the rose appears to be fading away.

Step 22 Darken and cool the color with a touch more Red Violet and add some darker color to the center (not too much) then a shadow stroke to the bottom of the bowl.

Step 23 On some, pull some cooler reds in from the sides to add more contrast and interest.

Step 24 Mottle a brighter green from Pine Green and touch Hansa and then add between and around the roses. Be casual and dance the color around.

Step 25 Add some brighter greens to the top rose buds. I will sometimes use a leaf suggestive shape, but I am thinking casual. Not perfect shapes.

Step 26 Add some Yellow Oxide with touch Hansa if desired to the roses. This will add the yellow color and give them more interest later.

Step 27 Add the yellow to the other rose buds. Smaller and not as much contrast.

Step 28 Mottle yellow with some white and begin to build the fronts to the roses. I started here because the center rose had not "tacked" enough to stroke. Could tack with hairdryer.

53

Step 29 Start on one side of the rose when you begin to build the center. Let the color soften as you stroke to the sides. Lost edges.

Step 30 Start the other side the same way. Here it hit some Red Violet from the center which I think looks great. Casual creates fun interest.

Step 31 Stroke the side roses with the same technique, just not as much white.

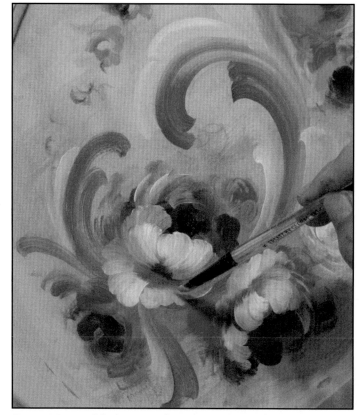

Step 32 Build the reaching petals with more white. Add a stroke of Red Violet prior like other lesson if desired or change!

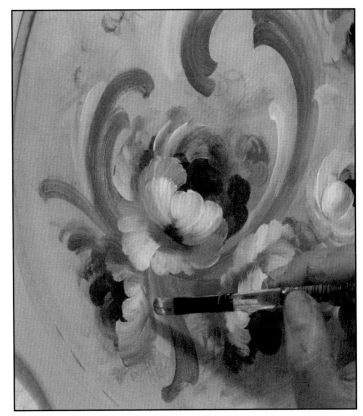

Step 33 Add some softer strokes of white to the side petals. Keep the colors and the strokes softer so not to compete with the center main rose.

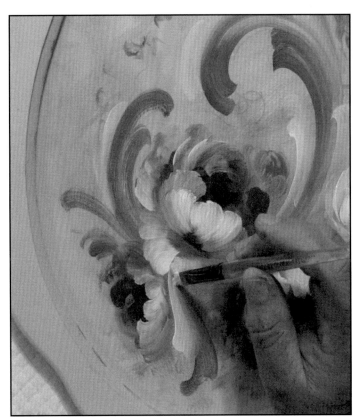

Step 34 Here I restated some white movement from the bottom scroll which I felt was getting lost.

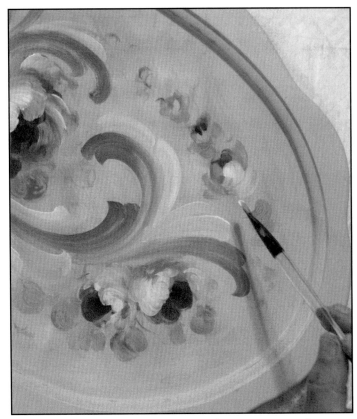

Step 35 I used the edging technique to make some edges on the light grey scroll strokes we applied earlier. This helps them stand out a little more.

Step 36 Add some edges to the light grey cap strokes. Add as much as you desire, just don't make more contrast than roses.

Step 37 Use the edging technique to bring out the white in the strokes in the center of the main root C. I didn't do this on the other lessons, but I liked it this time.

Step 38 Feather the white strokes into the main C with the chisel of the brush. Here I stroke sideways for some difference.

Step 39 Round up the top cap stroke with white and the edging technique.

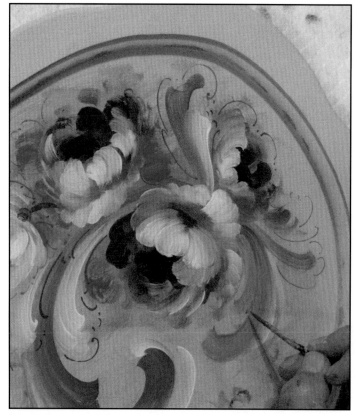

Step 40 Mottle a darker green with Pine Green and some Burnt Sienna and add the liner like the other lessons with the #3 quill.

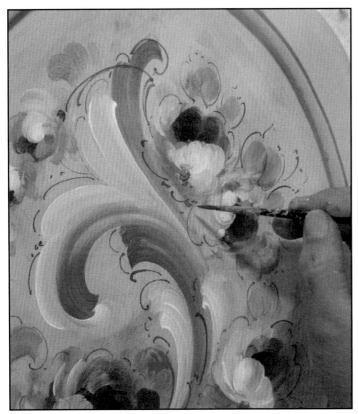

Step 41 Add stems with 2 or 3 strokes. Add the liner not always following exactly the outlines of the shapes. Keep it casual and step off edges to make it "airy".

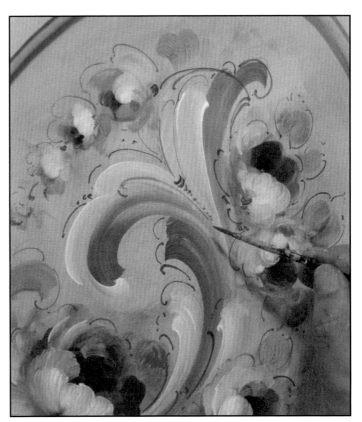

Step 42 I add a few tying strokes where the S and C come together. This is popular in Rogaland and Telemark. Keep it fun and interesting! Decorate.

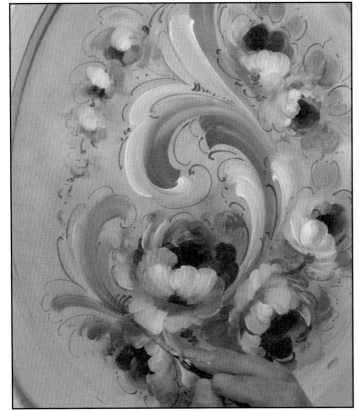

Step 43 More decoration. Look at the final photos for some liner work ideas, but keep is casual and try to "let go" have some fun.

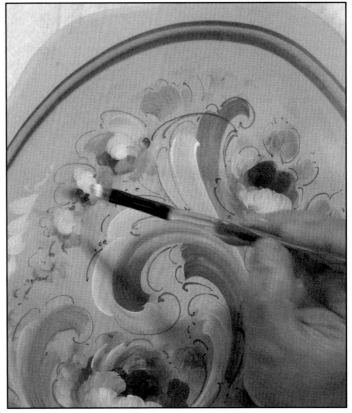

Step 44 Here I decided to build the smaller buds to the left side of the design. I add more white to give them more contrast.

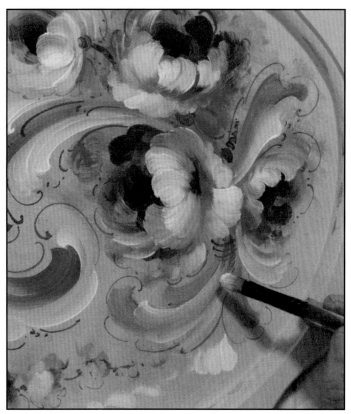

Step 45 Here I added more white to the scrolls around the center. Think of theses as other scrolls creating more movement.

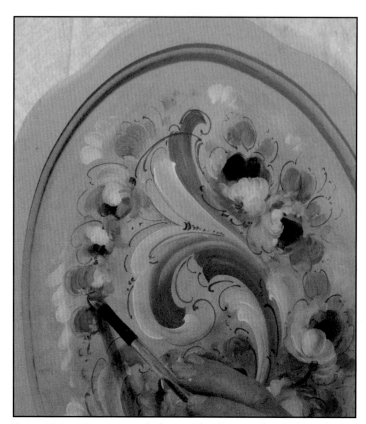

Step 46 I increased the reds down the left side because I felt the design was heavier with red on the right. So this helped balance the color. Always look and think color movement.

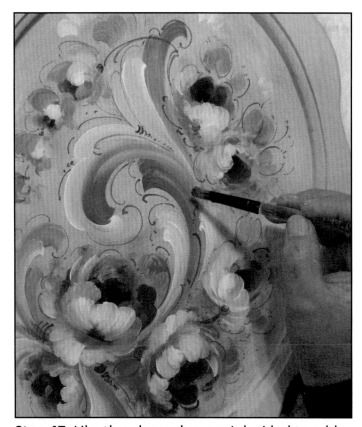

Step 47 Like the plaque lesson, I decided to add some last strokes of Yellow Oxide down the scroll to increase yellow and yellow movement. I like it!

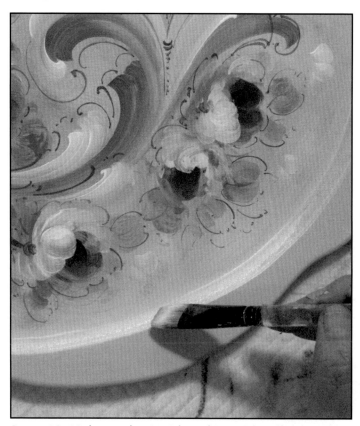

Step 48 Lighten the inside edge with white and touch yellow. Save some of this color for a stripe. Add toned green to the rim with light stripe (saved color) to finish the tray. Enjoy!

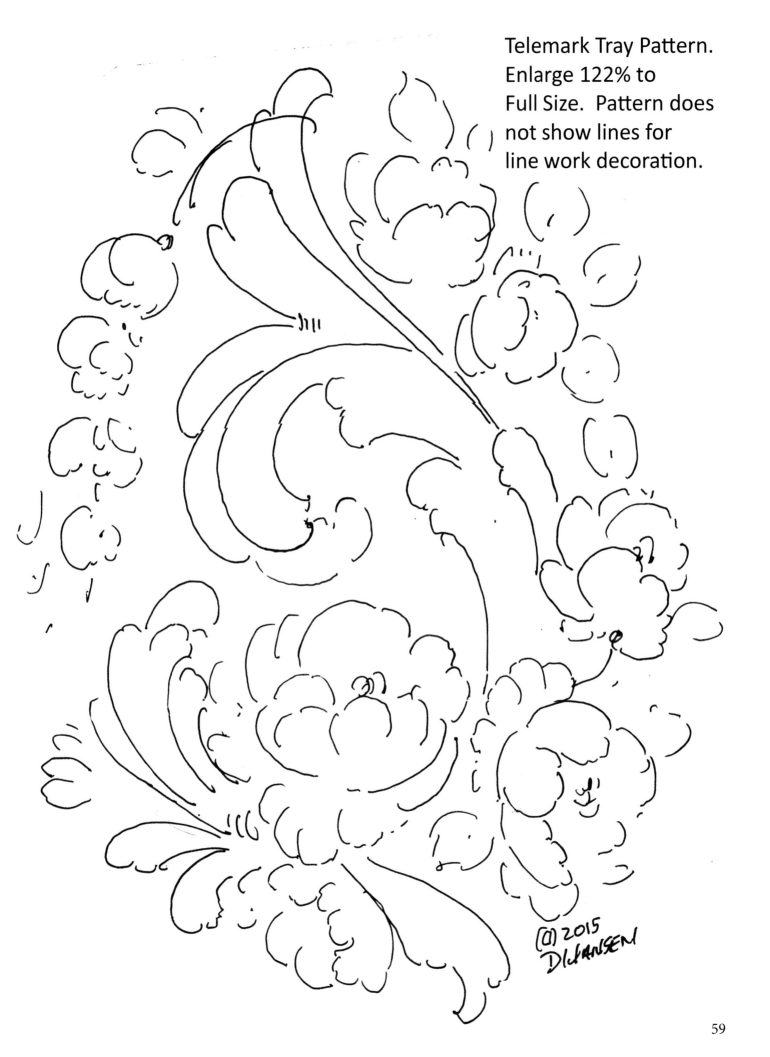

Telemark Tray Pattern.
Enlarge 122% to
Full Size. Pattern does
not show lines for
line work decoration.

(C) 2015
DicHANSEN

Paint It Simply - Art Videos Direct
Art and Painting Made Simple

Watch 100's of Videos each month for one low monthly subscription price.

2 week free trial subscription.

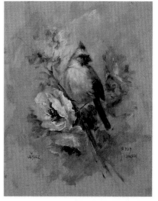
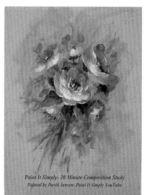

Paint It Simply- 20 Minute Composition Study
Painted by David Jansen- Paint It Simply YouTube

100's of Videos to watch with your monthly subscription. Some new never published. Monthly specials, discounts on art supplies, discounts on video purchases. Rent so to watch and paint. All this and more available to our subscribers!

Visit http://artvideosdirect.com

4 Educational Channels for the same Subscription

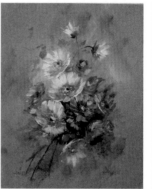
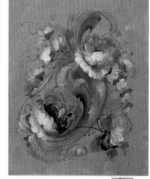

30 Minute Composition Studies- Paint It Simply YouTube
Painted by David Jansen

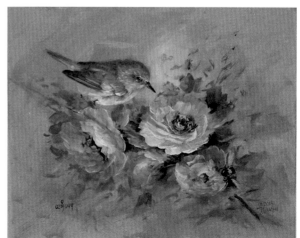